CREATE YOUR OWN JOURNAL

Spiritual Journey–Exploring my beliefs

Writing a New Chapter Journey–Learning from past mistakes

Achievement Journey–Creating new goals

Finding your life's purpose or true calling

Humanitarian Journey–Make a difference in the world

Chaotic Resolve Journey–Achieving inner peace

Mending Fences Journey–Righting my wrongs

Self-improvement Journey–Loving yourself through acceptance

Self-discovery Journey–Exploring your true creative passions

Overcomer's Journey–Conquering your fears

Destination Journey

N NE E SE S SW W NW

─── ✳ **10x Different Journals in 1** ✳ ───

Follow us on social media!

Tag us and use #piccadillyinc in your posts
for a chance to win monthly prizes!

This edition published by Piccadilly (USA) Inc.

Piccadilly (USA) Inc.
12702 Via Cortina, Suite 203
Del Mar, CA 92014
USA

10 9 8 7 6 5 4 3 2 1

Printed in Vietnam

ISBN-13: 978-1-62009-868-4

Dear Diary,

I admit it: writing in a journal can be a bit dull. (No offense.) You may not realize this, diary, but I spend more time staring at the blank page wondering what to write than I spend actually writing in you. So, I'm doing it differently this time. This time, I'm turning my journaling time into journeying time!

In these pages, I'll follow paths that lead me to discoveries I never saw coming and to memories I may have forgotten. It's like a "choose your own adventure" novel, except the adventure is my own life. If I'm in a reflective mood, for example, I'll go on a self-discovery journey. All I have to do is begin on the designated page, complete the self-discovery prompt, and skip ahead to next prompt until the journey is fulfilled. The journey ends with retrospectives that give me a chance to understand the big picture behind the journaling process.

This new journal will be so much more than a record of my daily thoughts—this new journal will make me a more thoughtful, more proactive person. And it will be more fun to write!

Sorry, blank page, there's nothing *blank* about me.

Create Your Journey

Destination Journey
Finding your life's purpose or true calling............Start on page 6

Humanitarian Journey
Make a difference in the world............Start on page 6

Overcomer's Journey
Conquering your fears............Start on page 7

Chaotic Resolve Journey
Achieving inner peace............Start on page 7

Achievement Journey
Creating new goals............Start on page 8

Self-discovery Journey
Exploring your true creative passions............Start on page 8

Writing a New Chapter Journey
Learning from past mistakes............Start on page 9

Mending Fences Journey
Righting my wrongs............Start on page 9

Self-improvement Journey
Loving yourself through acceptance............Start on page 10

Spiritual Journey
Exploring my beliefs............Start on page 10

Destination Journey: Retreat to your childhood. Make a list of all the things you thought you wanted to be when you were younger and why. List everything, even if it was a circus clown. *Turn to page 11*

Humanitarian Journey: What causes, charities or organizations are close to your heart and why? *Turn to page 11*

Overcomer's Journey: Write about your top 5 fears and how long you've had them. What effect do they have on your daily life? *Turn to page 12*

Chaotic Resolve Journey: Write about things that are making your life feel chaotic and how it got this way. *Turn to page 12*

Achievement Journey: What is the biggest goal for you in life? *Turn to page 13*

Self-discovery Journey: Write about what you love to do in your spare time. *Turn to page 13*

Writing a New Chapter Journey: What is something you need to let go of. What is haunting you or weighing you down? How can you make peace with this or rid yourself of these ghosts? *Turn to page 14*

Mending Fences Journey: Do you hurt others to feel better about yourself? Explain how and why you think you do this? *Turn to page 14*

Self-improvement Journey: Celebrate your strengths. Make a list of all your good qualities and strengths. *Turn to page 15*

Spiritual Journey: Write about your current beliefs and what they mean to you. Do you practice any form of religion? *Turn to page 15*

Destination Journey: Describe in your own words what you think a "calling or life purpose" means. Write if you think it's always related to a career or something else. *Turn to page 16*

Humanitarian Journey: Make a list of all the places you want to volunteer and why you want to volunteer there. *Turn to page 16*

Overcomer's Journey: Define your biggest fear. Develop a simple plan of action to address your fear. *Turn to page 17*

Chaotic Resolve Journey: Write about the most negative relationship in your life and what makes it negative. This can be any relationship: work, family, significant other or friend. *Turn to page 17*

Achievement Journey: What are your "current goals?" Write about your current goals in life and how you're pursuing them. *Turn to page 18*

Self-discovery Journey: If you had more time, how would you spend it? *Turn to page 18*

Writing a New Chapter Journey: Write about a past mistake that has taught you a valuable lesson. *Turn to page 19*

Mending Fences Journey: Do you admit when you're wrong in disagreements? Do you take responsibility for your role in the argument? Describe a fight that happened you wished you'd handled differently. *Turn to page 19*

Self-improvement Journey: Believe in yourself. Have you had a hard time believing in yourself? What can you do to believe in yourself more? *Turn to page 20*

Spiritual Journey: What are the basic principles of your belief system/religion?
Turn to page 20

Destination Journey: Make a "top 10" list of people who you admire (famous or not) and how their work inspires you. *Turn to page 21*

Humanitarian Journey: Spend the day volunteering somewhere and write about the experience. *Turn to page 21*

Overcomer's Journey: How do scary movies make you feel? Describe the scariest movie you've ever seen and if it had an emotional effect on you. *Turn to page 22*

Chaotic Resolve Journey: Now think about the last question and write about why you still have this relationship in your life. Can this relationship be repaired? If not, why are you still holding on? *Turn to page 22*

Achievement Journey: What is your proudest achievement in your life thus far? Why does it mean so much to you? *Turn to page 23*

Self-discovery Journey: What is one thing you've always wanted to do but haven't yet tried? *Turn to page 23*

Writing a New Chapter Journey: Look for ways to learn lessons each day. Good days or bad days there is something to gain from each day. What did you learn today? *Turn to page 24*

Mending Fences Journey: Do you participate in gossip or talk about people behind their back? Has this happened to you, if so how did it make you feel? *Turn to page 24*

Self-improvement Journey: What do you want to improve about yourself? Make a list and figure out how you can take healthy steps to work towards your self-improvement goals. *Turn to page 25*

Spiritual Journey: Do you believe in God? Write about your God and what he means in your life. *Turn to page 25*

Destination Journey: Write about what you do for a living now. Create a pro and con list of your work. Then ask your current boss or supervisor to write a list of your strongest qualities and areas that need improvement. *Turn to page 26*

Humanitarian Journey: Go to a children's hospital and play games with the kids, have story time or make them laugh. Document the emotional day here in the journal. *Turn to page 26*

Overcomer's Journey: Have you ever missed an opportunity because fear got the best of you? If so, write about it and what you should have done differently.
Turn to page 27

Chaotic Resolve Journey: Write your very own definition of peace. Not what the dictionary says but how peace would be described in your life. *Turn to page 27*

Achievement Journey: How have your goals changed over the last 5 years and why have they changed? *Turn to page 28*

Self-discovery Journey: Tap into your creative side. What new hobbies do you want to try? *Turn to page 28*

Writing a New Chapter Journey: What about your personality can get you into trouble? What specific trait/s causes you trouble and is this a reoccurring problem? *Turn to page 29*

Mending Fences Journey: Have you ever started a rumor about someone? Did you apologize to this person? Why did you start the rumor? *Turn to page 29*

Self-improvement Journey: Write about all the ways you're beautiful. Write a poem to yourself about your own unique beauty. *Turn to page 30*

Spiritual Journey: Do you appreciate other people's beliefs? Why is it important to show each other respect concerning those beliefs? *Turn to page 30*

Destination Journey: Make a list of the top 3 professions you would love to have. Then describe why you love them and what skills you have that would make you perfect for that job. Also describe how that work would make you feel like you have fulfilled your purpose. *Turn to page 31*

Humanitarian Journey: Think about how your skills can best serve the world and write a summary about how you can make a difference. *Turn to page 31*

Overcomer's Journey: Write about a "close call" you had in your life. What happened and what did you learn about yourself from it? *Turn to page 32*

Chaotic Resolve Journey: Would you describe yourself as a lover or fighter? How do you feel about that? *Turn to page 32*

Achievement Journey: Happiness is usually a goal for most people. What is your definition of happy and what makes you happy? *Turn to page 33*

Self-discovery Journey: What talents do you have? How do you feel about them? *Turn to page 33*

Writing a New Chapter Journey: Don't let your past mistakes dictate your future. Write about what mistakes you're going to leave in your rearview mirror.
Turn to page 34

Mending Fences Journey: If you've hurt someone and it ended a relationship or friendship, be the bigger person and apologize. Apologize and move on; you'll feel better. Then determine if you want this relationship back in your life–write about the outcome. *Turn to page 34*

Self-improvement Journey: Being happy is a choice. Choose to be happy. What ways can you start choosing to be happy? *Turn to page 35*

Spiritual Journey: Do you pray? How important is prayer in your life? What was the last thing you prayed about? *Turn to page 35*

Destination Journey: If you could interview someone from any profession, which profession would it be and what are a few of the questions you'd like to ask them? *Turn to page 36*

Humanitarian Journey: What do you think the world needs more of? What do you think the world needs less of? *Turn to page 36*

Overcomer's Journey: Write a letter to yourself about what you are most afraid of. Reassure and comfort yourself in this letter. *Turn to page 37*

Chaotic Resolve Journey: When you fight, do you fight with purpose? Are you fighting for a cause, a person or for yourself or do you just have petty fights out of anger? *Turn to page 37*

Achievement Journey: Are there any goals you're afraid to set and if so, what are they? *Turn to page 38*

Self-discovery Journey: Aristotle said, "Knowing yourself is the beginning of all wisdom." How much do you know about yourself? *Turn to page 38*

Writing a New Chapter Journey: Do you see the glass half empty or half full? Write about how you view the glass and how that shapes your daily life. *Turn to page 39*

Mending Fences Journey: Do you see the best or worst in people? Write about how you view others and how you feel about the way you view them. Do you look for flaws? *Turn to page 39*

Self-improvement Journey: Know your self-worth. Your worth is not a product of wealth or popularity. It is how you see yourself and knowing you're valuable. How worthy do you currently see yourself and how can you improve on it? *Turn to page 40*

Spiritual Journey: What makes you feel enlightened and uplifted? *Turn to page 40*

Destination Journey: Ask 3 people that know you; it can be friends, family or co-workers and ask them what they think you're good at or what they think your calling might be. Journal the questions you ask and their answer here. *Turn to page 41*

Humanitarian Journey: Write about what you think the best ways are to help the homeless. *Turn to page 41*

Overcomer's Journey: Research ways to overcome your biggest fear. Try at least 3 of those ways and write about if it helped or not. *Turn to page 42*

Chaotic Resolve Journey: Write down things you're angry about and why you feel anger towards it. *Turn to page 42*

Achievement Journey: Make a list of things that could be standing between you and your goals. What do you plan to do about it? *Turn to page 43*

Self-discovery Journey: Think about exploring. What do you want to explore further? *Turn to page 43*

Writing a New Chapter Journey: What have you had to start over? How did you feel about starting over, was it a relief or was it difficult? *Turn to page 44*

Mending Fences Journey: How healthy is your self-esteem? Describe your confidence. Does this shape how you view people? *Turn to page 44*

Self-improvement Journey: Accept your current situation and where you are in life now. You may not be where you want but at least you're still trying. Write about all the good things in your life right now. *Turn to page 45*

Spiritual Journey: Do you believe in "spirit animals" and if so what is your spirit animal? How do you connect with your spirit animal? If you don't know, then go in search of your spirit animal and write about your findings. *Turn to page 45*

Destination Journey: Write a letter to yourself 5 years from now describing where you want to be. *Turn to page 46*

Humanitarian Journey: Think about ways you can help the environment. Write a plan of action you can implement at some point in your life. *Turn to page 46*

Overcomer's Journey: Have a personal conversation with a close friend about your fear/s and get advice from them. Write the advice below. *Turn to page 47*

Chaotic Resolve Journey: How can you change your outlook about the things that make you angry? What can you do to improve here? *Turn to page 47*

Achievement Journey: Part of achieving your goals is having a clear, defined list. Remove unrealistic expectations but at the same time challenge yourself. Make sure your goals are attainable. Write about your goals. *Turn to page 48*

Self-discovery Journey: What is missing from your life? What do you need more of? *Turn to page 48*

Writing a New Chapter Journey: Stop beating yourself up. Mistakes are a part of life. Don't waste energy beating yourself up on mistakes. Instead acknowledge and move on. How do you beat yourself up over mistakes? *Turn to page 49*

Mending Fences Journey: Use the proverb, "people who live in glass houses shouldn't throw stones." Now write what this means to you and how it applies to your life. *Turn to page 49*

Self-improvement Journey: Write self-loving affirmations. Practice saying them to yourself every day and write about if they helped you. *Turn to page 50*

Turn to page 50

Spiritual Journey: Do you believe in astrology? If so, what's your sign? Write about why you do or do not believe in astrology and any impact it has on your life. *Turn to page 50*

Turn to page 50

Destination Journey: What is a reoccurring dream or aspiration for your life? Write about how it makes you feel. *Turn to page 51*

Humanitarian Journey: Do something nice for a friend. Write about why you chose that friend and what they mean to you. *Turn to page 51*

Overcomer's Journey: Find an online forum that deals and talks openly about one specific fear you have. Participate in this online help community for at least a week. Write about if it helped you, what happened and if anonymity helped you open up. *Turn to page 52*

Chaotic Resolve Journey: What do you have that is unresolved? Write about unresolved things in your life that are keeping you from inner peace. *Turn to page 52*

Achievement Journey: Seeing your dreams and goals daily reminds you what you're working for. Find a creative way to display your goals and positive affirmations that will help you reach your goals. How will you do this? *Turn to page 53*

Self-discovery Journey: What are your favorite hobbies and how do they make you feel? *Turn to page 53*

Writing a New Chapter Journey: Mistakes are different than bad decisions. Most mistakes are unintentional. Write about bad decisions you keep repeating and how you need to correct this behavior. *Turn to page 54*

Mending Fences Journey: Stop trying to change other people. Make an effort to accept people the way they are. Why do you feel the need to change others? *Turn to page 54*

Self-improvement Journey: Don't feed your insecurities. Identify them and write about ways to overcome those insecurities. What are the top 3 ways you can overcome your insecurities? *Turn to page 55*

Spiritual Journey: Be still. Try deep meditation, combined with breathing exercises or other practices that help you still the mind. Write about this journey. *Turn to page 55*

Destination Journey: If you could volunteer as an intern for a day in a field that touches your heart, would you? What field would you intern in and why did you choose that field? *Turn to page 56*

Humanitarian Journey: What's the nicest thing someone has ever done for you? Do you have any plans to pay it forward? *Turn to page 56*

Overcomer's Journey: Try meditating. If you don't know how, research it online or ask for help. There are a few audio smart apps for your phone or YouTube videos. Write about your meditation experience. *Turn to page 57*

Chaotic Resolve Journey: How can you start resolving the unresolved areas in your life? Write about where you plan to start. *Turn to page 57*

Achievement Journey: Reduce your distractions. Make a list of things that distract you. Now write about how you can avoid those distractions. *Turn to page 58*

Self-discovery Journey: If you could travel anywhere in the world you want, where would you go and why? What speaks to you about this place? *Turn to page 58*

Writing a New Chapter Journey: Adjust your focus. Sometimes errors and mistakes come from lack of focus or distractions. Figure out what is distracting you. Write about distractions in your life that often lead to mistakes. *Turn to page 59*

Mending Fences Journey: Have you and a family member had a falling out? Have you been able to rectify that relationship? How is your relationship now? *Turn to page 59*

Self-improvement Journey: Don't try and please everyone. Are you a people pleaser? Do you need others' approval? Write about ways you're going to correct this behavior. *Turn to page 60*

Spiritual Journey: You need to find a way to connect to others that connect to your spiritual similarities. How can you do this? *Turn to page 60*

Destination Journey: What is your definition of hard work? Do you think rewarding work is always hard? *Turn to page 61*

Humanitarian Journey: Give out at least 25 or more compliments to people you know and strangers all in one day. Be mindful and put thought into the compliment. Write about how it felt being kind all day. *Turn to page 61*

Overcomer's Journey: Read a book, blog or article that deals with a particular fear you have. Write about what you read and if it helped you. Did you learn anything? *Turn to page 62*

Chaotic Resolve Journey: Do you lash out at people? What have you ever lashed out about? *Turn to page 62*

Achievement Journey: Don't procrastinate. What do you often put off or avoid that leads to procrastination? *Turn to page 63*

Self-discovery Journey: Wake up and seize the day. What does this mean to you and write about how you seized the day. *Turn to page 63*

Writing a New Chapter Journey: How do you feel when you make a mistake? Do you feel worse if it's a mistake at work or in your personal life? *Turn to page 64*

Mending Fences Journey: Practice the art of forgiveness. Don't hold grudges. How easy is it for you to forgive others? *Turn to page 64*

Self-improvement Journey: Create a journey for yourself. A journey that is devoted to exploring and learning more about yourself. What will you do first?
Turn to page 65

Spiritual Journey: What type of energy do you attract and why do you think you attract this energy. How can you attract more of what you want to you? *Turn to page 65*

Destination Journey: How important is money to you and how does it influence what you deem your life's calling or purpose to be? *Turn to page 66*

Humanitarian Journey: What's the nicest thing you've ever done for someone? How did it feel? *Turn to page 66*

Overcomer's Journey: What one new thing can you try that will help you overcome your fear/s? *Turn to page 67*

Chaotic Resolve Journey: Do you get enough sleep? Evaluate your sleep habits and look for ways to improve your sleep. Write about habits you need to change. *Turn to page 67*

Achievement Journey: Make the most of each day and don't forget to schedule in time to relax. Write about how you can make better use of each day and your favorite ways to relax. *Turn to page 68*

Self-discovery Journey: Learn a new language. What language speaks to you and why? *Turn to page 68*

Writing a New Chapter Journey: How do you cope with most mistakes? Is there any specific mistake you haven't made peace with yet? *Turn to page 69*

Mending Fences Journey: Have you ever burned a bridge and later regretted it? Who did you burn with and how can you repair this bridge? *Turn to page 69*

Self-improvement Journey: Participate in a 30-day challenge. Challenge yourself. You've seen them all over social media, find one you like and accept the challenge. Write about the challenge you're going to try. *Turn to page 70*

Spiritual Journey: Do you believe in karma? What is your definition and how is your current karma? *Turn to page 70*

Destination Journey: How important is family to you? What kind of family (if any) do you want to start and how will this impact your purpose? *Turn to page 71*

Humanitarian Journey: Stay positive an entire day, from start to finish. No negative thinking, speaking or actions. Write about your day and how it felt to stay positive and did this make your day better? *Turn to page 71*

Overcomer's Journey: Have you tried something spiritual like praying when you're afraid? Write about how spirituality or prayer impacts your fears. *Turn to page 72*

Chaotic Resolve Journey: Is there someone in your life you haven't forgiven? Forgive them and move on. Write about how forgiveness makes you feel. *Turn to page 72*

Achievement Journey: Reward yourself for milestones. As you progress towards your goals, you should reward yourself for your accomplishments. Write about your favorite ways to reward yourself. *Turn to page 73*

Self-discovery Journey: Think back to your childhood, what made you happy? What did you enjoy doing and how has that changed as you've gotten older? Write about how you're still similar to your younger self. *Turn to page 73*

Writing a New Chapter Journey: Take care of yourself. Lack of sleep, sitting too long and poor diet can lead to mistakes in your work. Write about ways you need to take better care of yourself. *Turn to page 74*

Mending Fences Journey: A golden rule to live by is, "treat others how you would like to be treated." Do you live by these words? Create your own golden rules below and start implementing them into your life. *Turn to page 74*

Self-improvement Journey: Martin Luther King Jr. said, "You don't have to see the whole staircase, just take the first step." What should your first step be? *Turn to page 75*

Spiritual Journey: Do you recognize your creator? Describe your creator and how you came to this reality? *Turn to page 75*

Destination Journey: When people ask for your help, what is it usually for? Why do you think they come to you? *Turn to page 76*

Humanitarian Journey: What kind of mentor do you think you'd be? What's the best advice you'll give someone you're mentoring? *Turn to page 76*

Overcomer's Journey: Write a few things you're not afraid of, that other people are usually afraid of. Why don't they bother you? *Turn to page 77*

Chaotic Resolve Journey: When you hear the word "peace" what images or objects come to mind? Write down all the things or images you think of that evoke a spirit of peace within you. *Turn to page 77*

Achievement Journey: Be willing to sacrifice. Sometimes in life sacrifices must be made to achieve your dreams. What sacrifices do you think you will have to make and what will be the hardest sacrifice? *Turn to page 78*

Self-discovery Journey: At the end of your life, what would you regret not having enough time to do? *Turn to page 78*

Writing a New Chapter Journey: Find the silver lining. Sometimes it's hard to see it but there's always one. This will help you gain a better understanding of what's going on and mature. Describe the silver lining in your last mistake. *Turn to page 79*

Mending Fences Journey: Have you ever taken credit for something that wasn't yours or stolen something from someone? Explain the situation and how it ended. *Turn to page 79*

Self-improvement Journey: Experiment with a new style. Try something new and fun, be brave and don't hold back. Write about what you plan to do. *Turn to page 80*

Spiritual Journey: Does your spirituality have a direct connection to your happiness? Write about the link between the two. *Turn to page 80*

Destination Journey: What do you feel a deep connection to? What touches your soul and impacts you profoundly? *Turn to page 81*

Humanitarian Journey: Write about how you can help out in your own community. What does your community need and how can you make a difference? *Turn to page 81*

Overcomer's Journey: Help a friend try and overcome a fear they have. Write about the details. *Turn to page 82*

Chaotic Resolve Journey: Where is your place of serenity and why does it make you feel this way? *Turn to page 82*

Achievement Journey: Hold yourself accountable. Make sure you check in with yourself, stay focused and evaluate your mindset. In what ways do you need to hold yourself accountable? *Turn to page 83*

Self-discovery Journey: What gets you excited and makes you feel alive? *Turn to page 83*

Writing a New Chapter Journey: Reshape your goals. Use what you've learned from past mistakes to reshape and redefine what you want from life. What is one of your goals that needs reshaping? *Turn to page 84*

Mending Fences Journey: Practice compassion. Write about ways you can show compassion to others and a plan to put it into motion. *Turn to page 84*

Self-improvement Journey: Do you have a favorite blog to read? Write about why you love this blog and what you get from it. *Turn to page 85*

Spiritual Journey: Do you go to church? How do you feel about church? Write about your most memorable experience at church. *Turn to page 85*

Destination Journey: Watch a documentary online about the top 3 professions you love or think you would be good at. Write about what you learned after watching the documentaries. *Turn to page 86*

Humanitarian Journey: Have you ever donated blood or been a part of a blood drive? Do you think it's important to donate blood and how can you raise awareness? *Turn to page 86*

Overcomer's Journey: Take a leap of faith. Write about your leap. *Turn to page 87*

Chaotic Resolve Journey: Practice the art of mindfulness. Stop worrying about the future or things beyond your control. Read about the principles of mindfulness and start applying them to your life. Write about if you think it will help you. *Turn to page 87*

Achievement Journey: Don't allow bumps in the road or setbacks to derail your journey or focus. There will always be challenges in anything you do but the key is to keep moving forward. What are some of the toughest challenges you've faced and what could you have done better? *Turn to page 88*

Self-discovery Journey: If money was not an issue, how would you spend your time? *Turn to page 88*

Writing a New Chapter Journey: Make each day count. Get up and live with purpose. Write about what you will do differently to get the most out of each day. *Turn to page 89*

Mending Fences Journey: Have you ever taken advantage of someone or been taken advantage of? What did you do and how did the other person react? What did you learn from this? *Turn to page 89*

Self-improvement Journey: Inspire others who are feeling low. Making others feel good about themselves, makes us feel good about ourselves. What can you do to inspire others? *Turn to page 90*

Spiritual Journey: Describe what you think a soul is and then write about your very own soul. *Turn to page 90*

Destination Journey: What do you think you will regret the most if you didn't try or accomplish and why? *Turn to page 91*

Humanitarian Journey: Find an important cause in another country. Research it and write a thoughtful post, share it to your social media. Tell others how they can help and get involved. Write about the kind of response you received. *Turn to page 91*

Overcomer's Journey: Try and understand your fear. Write what scares you most about it. Identify some triggers that activate that fear. Determine your level of this particular fear. Write about your discovery. *Turn to page 92*

Chaotic Resolve Journey: What places cause you stress or steal your peace? How can you stop allowing these places to have a negative effect on you? *Turn to page 92*

Achievement Journey: Never give up. It's in the moments we want to quit the most that we are the closest to achieving our goals. Write about a time you gave up and wish you hadn't. *Turn to page 93*

Self-discovery Journey: What changes would you like to see in the world and how can you contribute to those changes? *Turn to page 93*

Writing a New Chapter Journey: You can have no success without failure. It's better to have a life full of small failures that you learned from, rather than a lifetime filled with the regrets of never trying. What would you regret never trying? *Turn to page 94*

Mending Fences Journey: How hard is it for you to apologize to people? *Turn to page 94*

Self-improvement Journey: How is your mental health? Mental health is very important to your overall well-being. Start implementing mental health practices into your life. What practices interest you? *Turn to page 95*

Spiritual Journey: Do you believe in soulmates? Do you think soulmates have a spiritual connection, why or why not? *Turn to page 95*

Destination Journey: Write about what your greatest strengths, attributes and qualities are. *Turn to page 96*

Humanitarian Journey: What kind of neighbor are you? Write about ways you can be more neighborly and what thoughtful things you can do to help out a neighbor in need. *Turn to page 96*

Overcomer's Journey: Think about one of your fears. Figure out how you can use this fear to benefit you. Write a plan to turn your fear into motivation. *Turn to page 97*

Chaotic Resolve Journey: Lighten up. Do you take things too seriously or take yourself too seriously? Create a plan below that will help you learn to be more flexible. Write about ways you can lighten up. *Turn to page 97*

Achievement Journey: How much do you want it? When you're creating goals and dreams for your life you need to ask yourself some questions. The biggest one is: Do you want it enough to work hard enough to get it? How much do you really want what you're striving for? *Turn to page 98*

Self-discovery Journey: How do you feel about writing? What kind of writer do you think you are? *Turn to page 98*

Writing a New Chapter Journey: Think positively. Your thinking can shape your actions. Write about something you need to start thinking positively about.
Turn to page 99

Mending Fences Journey: Have you taken someone, something or a position for granted? How does the saying, "don't know what you've got until it's gone" apply to you? *Turn to page 99*

Self-improvement Journey: Stop insulting yourself and speaking negatively about yourself in front of others. In what ways have you been negative towards yourself over the past few years? *Turn to page 100*

Spiritual Journey: How do science and man-made theories line up with your belief system? *Turn to page 100*

Destination Journey: What sacrifices are you willing to make in order to fulfill your purpose? What struggles are you willing to endure? *Turn to page 101*

Humanitarian Journey: Find a business you like that donates part of their profits to charity like Grace & Lace, Pura Vida or H&M. You can search online for a company that you like and that supports something you believe in. Write about what why you like and support this company and the good works they do with profits. *Turn to page 101*

Overcomer's Journey: Is your fear standing in the way of your goals or dreams? Write about it. *Turn to page 102*

Chaotic Resolve Journey: Keep your emotions in check. Figure out what your emotional triggers are and how they are impacting your life negatively. Don't keep your emotions bottled up, find healthy outlets for your emotions. Write about those outlets. *Turn to page 102*

Achievement Journey: Do some research and pick a book that appeals to you on the topic of working hard and attaining your dreams. Read it. Did this book help? *Turn to page 103*

Self-discovery Journey: If you were to write your first book, what would it be about? *Turn to page 103*

Writing a New Chapter Journey: Nothing is as bad as it seems. Don't magnify your mistakes, rather shift your focus to the solution or lesson. Do you blow mistakes out of proportion? Write about a time you did this. *Turn to page 104*

Mending Fences Journey: Write a few original song lyrics to your last bad breakup and give the song a title. Did writing help you sort through the pain? *Turn to page 104*

Self-improvement Journey: Don't compare your appearance with someone else's. Everyone is different. Write about all your unique traits that are special to you. *Turn to page 105*

Spiritual Journey: Think about all the religions in the world. Pick a religion different than your own and read a few of their principles. How do they compare with your belief system? *Turn to page 105*

Destination Journey: What is your definition of success? Write it in your own words. Then find one photo (from a magazine, online, etc.) that perfectly sums up your true idea of success and paste it below your definition below. *Turn to page 106*

Humanitarian Journey: Volunteer at an animal shelter for a day or more. Write about the experience and how you felt. If you can't volunteer, write about how you feel about animal shelters and how they can get better. *Turn to page 106*

Overcomer's Journey: Determine if your fear is real or if it's just a bunch of "what if's." If your fear doesn't have substance, then it is probably just worry disguised as fear. Separate your worry from real fear. *Turn to page 107*

Chaotic Resolve Journey: Stop comparing your life to another person's life. Create a list of all the things you love and are thankful for in your life. *Turn to page 107*

Achievement Journey: If you could ask any successful person in the world one question, who would it be and what would you ask? *Turn to page 108*

Self-discovery Journey: How do you feel about poems? Write a short poem about your life right now. *Turn to page 108*

Writing a New Chapter Journey: Create your own support network. You should have a trusted group of friends and family to provide you support. You can talk to them, seek advice and receive comfort when you need a boost. Who should be in your support network and why? *Turn to page 109*

Mending Fences Journey: Do you listen to others and value people's opinions other than your own? How can you improve your listening skills and value other's ideas more? *Turn to page 109*

Self-improvement Journey: Practice the type of love you want to attract into your life. Where and how can you start practicing putting more love into the world? *Turn to page 110*

Spiritual Journey: Have you read the Bible or any parts of the Bible? How do you feel about the Bible and do you have a favorite scripture? *Turn to page 110*

Destination Journey: What myths about happiness do you think are holding you back? What is true happiness, describe it in its simplest form. *Turn to page 111*

Humanitarian Journey: Start a recycling program in your own house. If you already recycle, then try and get others involved. Write about why you think recycling is important. *Turn to page 111*

Overcomer's Journey: Write about toxic things in your life. Sometimes negative things can manifest fear. Write about how these toxic things could be contributing to your fear and how you can address this. *Turn to page 112*

Chaotic Resolve Journey: Write about how you can be nicer to more people on a daily basis. *Turn to page 112*

Achievement Journey: Accept constructive criticism. You never want to listen to negativity, but you should always accept helpful criticism. What constructive criticism have you received and did it help you? *Turn to page 113*

Self-discovery Journey: Go back and read the poem you just wrote, what is missing from your life that you want reflected in that poem? *Turn to page 113*

Writing a New Chapter Journey: Dust yourself off and get back out there. Life will knock you down and often times it's in the form of a mistake or setback. Mistakes are proof of your progress, it's practice in motion and evidence you're trying. Write about something you did over and over again until you got it right. *Turn to page 114*

Mending Fences Journey: How easy are you to get along with? What are some things you need to do to improve your relationships with others? *Turn to page 114*

Self-improvement Journey: Do something nice for yourself each day. Even if it is small, be mindful and treat yourself kind. What nice thing will you do for yourself today? *Turn to page 115*

Spiritual Journey: How do you apply your spiritual beliefs and principles to your life? *Turn to page 115*

Destination Journey: Describe the biggest leap of faith you've taken thus far in your life. Write about 2 or 3 new leaps of faith you may have to take to find your purpose? *Turn to page 116*

Humanitarian Journey: How do you feel about small businesses and local farmers? Try and research local farmers in your area and write about what you learned. *Turn to page 116*

Overcomer's Journey: Sometimes laughter helps overcome fear. What things can you do to start laughing at yourself? *Turn to page 117*

Chaotic Resolve Journey: Practice relaxation techniques and implement them into your life. Yoga, meditation, breathing or any technique. Write about what technique you plan to try and how you think it will help. *Turn to page 117*

Achievement Journey: Don't accept "good enough" If you are going through the motions of life but you don't feel like you're living, then you need to evaluate your life. Don't settle for a life you don't want; rather work for a life you'll love. Where do you think you've settled for less than you wanted? *Turn to page 118*

Self-discovery Journey: What was the craziest idea for your life you had as a child? Does it still seem crazy and if so why? *Turn to page 118*

Writing a New Chapter Journey: Not all mistakes involve work, some are relationships. Have you ever made a mistake in a relationship? What did you do? *Turn to page 119*

Mending Fences Journey: Do you have any prejudices that make you alienate specific people for one thing or another? Practice acceptance. In life, we have to learn to agree to disagree. Look at yourself in the mirror, now write about what you see. *Turn to page 119*

Self-improvement Journey: Create a cheerful environment. Whatever makes you smile, put that into your special place. Fresh flowers, candles, extra pillows—anything goes! How will you create a cheerful environment? *Turn to page 120*

Spiritual Journey: Do you believe in Heaven and Hell? Why or why not? *Turn to page 120*

Destination Journey: Take at least 3 online quizzes about finding your purpose. Make sure they're from different sources and write about the experience and findings below. *Turn to page 121*

Humanitarian Journey: Have you ever volunteered at a shelter? What do you know about shelters and do you have any plans to volunteer in the future? *Turn to page 121*

Overcomer's Journey: Educate yourself about a specific fear you have. What did you learn? *Turn to page 122*

Chaotic Resolve Journey: Become more enlightened. Write about things you're going to try on your journey of enlightenment. *Turn to page 122*

Achievement Journey: Remove complacency from your life. Complacency is dangerous and can at times kill your dreams. Do you feel like you've ever been complacent? *Turn to page 123*

Self-discovery Journey: Take an artistic class. It can be free or not but take at least one class in or around your community that requires you to be artistic in some way. Write about your experience. *Turn to page 123*

Writing a New Chapter Journey: Don't blame others. You need to own up to your mistakes. Do you often blame others for your mistakes? *Turn to page 124*

Mending Fences Journey: Keep your ego in check. Confidence is healthy, but conceit is cancerous. Are you conceited? What makes you feel confident? *Turn to page 124*

Self-improvement Journey: Spoil yourself once in a while. Buy yourself something nice, splurge on a delicious dinner or a mini getaway. You need to dedicate some time to spoil yourself and appreciate yourself more. What is your favorite way to get spoiled? *Turn to page 125*

Turn to page 125

Spiritual Journey: How important is forgiveness in your spiritual journey? Do you practice forgiveness? Do you have someone you need to forgive, or does someone need to forgive you? *Turn to page 125*

Turn to page 125

Destination Journey: Have you ever read a book that has helped you figure out your calling or passion? What was the name of the book and write about how it touched you? *Turn to page 126*

Humanitarian Journey: Donate something of your own to charity. Write about what you donated and where you donated it. *Turn to page 126*

Overcomer's Journey: What happens to you when you feel afraid? What are the symptoms of your fear? *Turn to page 127*

Chaotic Resolve Journey: Are you mad at yourself about something? Write about ways you're too hard on yourself and how you can forgive and ease up your self-expectations. *Turn to page 127*

Achievement Journey: Write about goals you've recently accomplished. *Turn to page 128*

Self-discovery Journey: Think about the past few years of your life. Did you make yourself any promises you didn't keep that would have made your life feel more fulfilled? *Turn to page 128*

Writing a New Chapter Journey: If you make a mistake you should try and correct it yourself. Do you usually correct your own mistake, or do you just leave it alone? *Turn to page 129*

Mending Fences Journey: Do something nice for someone who cannot pay you back. Write about your experience. *Turn to page 129*

Self-improvement Journey: Get a picture of the person you want to become and make a plan to move in that direction. What are your first steps? *Turn to page 130*

Spiritual Journey: Make a list of your values. Include what you think is right and wrong behavior. *Turn to page 130*

Destination Journey: Are your heart and your head ever on the same page when it comes to your life? Which do you follow? Write about a few times you should have listened to your heart more. *Turn to page 131*

Humanitarian Journey: Write about what causes going on in the world today trouble you. If you had unlimited means how would you contribute to make a difference. *Turn to page 131*

Overcomer's Journey: Write something positive about fear you're facing. Write about some positive aspects that will come from your fear or addressing your fear. *Turn to page 132*

Chaotic Resolve Journey: Set reasonable goals. If your goals or to-do lists are impossible in the time frame you've set, then adjust. Don't set yourself up for failure. Do you set unreasonable expectations for yourself? *Turn to page 132*

Achievement Journey: Find inspiration. Create inspirational things you can come back to when you need to be inspired. What always inspires you? *Turn to page 133*

Self-discovery Journey: Do you make New Year's resolutions? What resolution keeps coming up year after year that you're not accomplishing? Do any of your resolutions cause you to make drastic changes? *Turn to page 133*

Writing a New Chapter Journey: What bad habits do you have that could lead to you making mistakes in any area of your life? *Turn to page 134*

Mending Fences Journey: Do you have unresolved inner conflict that makes you lash or act out at times? Have you thought about talking to someone about this conflict? Research ways you can resolve your inner conflict and write about how you can take steps to start this journey. *Turn to page 134*

Self-improvement Journey: Don't let yourself go. Love yourself enough to make an effort, especially with hygiene. This means taking care of yourself. How can you take better care of yourself? *Turn to page 135*

Spiritual Journey: What does the word "faith" mean to you? What do you have faith in? Have you ever taken a leap of faith? *Turn to page 135*

Destination Journey: Create and write a "mission statement" for your life and write it below. *Turn to page 136*

Humanitarian Journey: Find a celebrity you admire. Find out what charities or causes are important to them and document your findings below and if they align with causes close to your heart. Did they motivate you to help in any way? *Turn to page 136*

Overcomer's Journey: Do it afraid. Do something you're afraid of then write about the experience. *Turn to page 137*

Chaotic Resolve Journey: Don't waste energy. Take stock of your life and look at things that are draining you of your energy and wasting valuable time. Make a list of things that are taking up too much time and not adding anything beneficial to your life. Make a plan to remove it. *Turn to page 137*

Achievement Journey: Don't wait, make it happen. Be proactive in your life and with your goals. How can you start being proactive today? *Turn to page 138*

Self-discovery Journey: What is your idea of fun? How much fun do you allow yourself to have? Is your idea of fun centered around hobbies, passions or something else? *Turn to page 138*

Writing a New Chapter Journey: Never be afraid to take a chance. Don't let fear of failure hold you back. Write about a time your fear of failure held you back.
Turn to page 139

Mending Fences Journey: Don't engage arguments. Avoiding conflict, means less strife and this is a great way to avoid hurting someone. Write about other ways you can avoid conflicts. *Turn to page 139*

Self-improvement Journey: It's ok to do things by yourself. Have the courage to grab a bite alone, see a movie or take a walk in the park. What things are you afraid to do alone that you are going to start doing? *Turn to page 140*

Spiritual Journey: What awakes your inner self? Go in search of things, practices or teachings that wake-up your spiritual side. Write about what you learned on your search. *Turn to page 140*

Destination Journey: Write about a person who you think has lived their life to the fullest and why you think that. Give specific examples of how they didn't waste a moment. *Turn to page 141*

Humanitarian Journey: Pick a cause about a disease that has touched you, your family or a friend in some way. Come up with a way to help the cause. Develop a creative way to raise awareness and write about what you did and why you chose to help that specific disease. *Turn to page 141*

Overcomer's Journey: Research and change some of your bad habits. Habits that could be contributing to fear, like procrastination or lack of sleep. Write about the changes you plan to make. *Turn to page 142*

Chaotic Resolve Journey: Unplug. Reduce the amount of time you spend on your devices, specifically the internet and social media. Whether it's one hour a day or one full day a week, create a plan to unplug. Write about that plan and any challenges you foresee. *Turn to page 142*

Achievement Journey: Perfection doesn't exist. It's ok to make a mistake, have a failure or start over. Don't strive for perfection, rather just be the best you possible. Write about your best strengths. *Turn to page 143*

Turn to page 143

Self-discovery Journey: Write about your natural creative abilities and how you want to develop them more. *Turn to page 143*

Turn to page 143

Writing a New Chapter Journey: Have you ever loved someone you thought was a mistake? Was the mistake worth making? *Turn to page 144*

Mending Fences Journey: Have you ever participated in online bullying or harassing of someone? Whether you have or have not create a social media post that is uplifting and discourages others from bullying. Write about the feedback your post received. *Turn to page 144*

Self-improvement Journey: Write about your most embarrassing moment and what you learned from it. *Turn to page 145*

Spiritual Journey: Practice gratitude. Find something each day to be thankful for. What are you thankful for today? *Turn to page 145*

Destination Journey: Part 1 - Spend an entire day people watching. Make sure you change locations at least 5 times and specifically look at people who have jobs you wouldn't consider. Journal below interesting things you saw. *Turn to page 146*

Humanitarian Journey: Have you ever run for a marathon? If so, write about the experience and if you would do it again. If not, write about a marathon you'd considering running in and why. *Turn to page 146*

Overcomer's Journey: Write a nursery rhyme about yourself with your fear as the villain. Put a face on your fear and create a small story where you come out victorious. *Turn to page 147*

Chaotic Resolve Journey: Learn to say NO and don't overcommit yourself. Saying yes or overcommitting when you're stretched too thin, creates unwanted stress. Commit to things that are important to you and things that need your time. Write about things you have problems saying "no" to. *Turn to page 147*

Achievement Journey: Eliminate mental roadblocks and negative thinking. Sometimes we are our own worst enemy. Remove thoughts and overthinking that makes you doubt yourself. How have you been your own worst enemy? *Turn to page 148*

Self-discovery Journey: Do you want to try and create a future out of any of your creative abilities? Why or why not? *Turn to page 148*

Writing a New Chapter Journey: What has been the biggest lesson you've learned in mistakes concerning money? *Turn to page 149*

Mending Fences Journey: Describe ways you feel socially awkward and why you feel this way. *Turn to page 149*

Self-improvement Journey: Are you fighting any personal battles? Write about the battles you're facing and how you plan to gain ground. *Turn to page 150*

Spiritual Journey: What do you find uplifting? *Turn to page 150*

Destination Journey: Part 2 - Reflect on one person who struck or touched you during your day of people watching. Write about what they did and why it moved you. *Turn to page 151*

Humanitarian Journey: How do you feel about the school system? What improvements or changes do you think should be made and why? *Turn to page 151*

Overcomer's Journey: Find and practice a breathing exercise. Utilize this exercise to help you next time you become afraid. Write how it helped you. *Turn to page 152*

Chaotic Resolve Journey: Find more balance. Work hard, play hard and rest. Write about what area of your life feels out of balance and what you can do to fix that. *Turn to page 152*

Achievement Journey: Eliminate the "fear of failure." Fear of failure can lead to you not pursuing your dreams. Think of success on the other side of fear. Even if you fail, try again and again. What are you afraid of failing? *Turn to page 153*

Self-discovery Journey: How does art inspire you? *Turn to page 153*

Writing a New Chapter Journey: Do you keep making the same mistakes over and over? What is the mistake and why do you think this keeps happening?
Turn to page 154

Mending Fences Journey: Do you take things out on other people? If so, what causes you to do this? *Turn to page 154*

Self-improvement Journey: Find new ways to inspire yourself. What are some new ways you can inspire yourself? *Turn to page 155*

Spiritual Journey: Do you believe in signs? Have you ever been given a sign and if so what was it? Where do you think the sign came from? *Turn to page 155*

Destination Journey: Write about a time in your life you were the happiest.
Turn to page 156

Turn to page 156

Humanitarian Journey: What is the greatest gift you can give your fellow man?
Turn to page 156

Turn to page 156

Overcomer's Journey: Change your thinking. Don't magnify your fears. Write down bad thinking habits you have that make your fears bigger than they are. Address those bad habits. *Turn to page 157*

Chaotic Resolve Journey: Declutter your life and surroundings. Too much clutter, junk and stuff—can take away from the enjoyment of life. Clean up your surroundings (includes desk) and purge things from your life you don't need. Write about your plan for decluttering. *Turn to page 157*

Achievement Journey: Don't stay in your comfort zone. Your goals should push you out of your comfort zone. Write about a new goal that is completely out of your comfort zone. *Turn to page 158*

Self-discovery Journey: Write about someone who you admire that is very creative and how their work influences your life. *Turn to page 158*

Writing a New Chapter Journey: What was your most embarrassing mistake? What did you learn from the embarrassment? Turn to page 159

Mending Fences Journey: Have you ever retaliated against someone? What was it for and how did the retaliation make you feel? What can you do today to recover from this? *Turn to page 159*

Self-improvement Journey: Listen to yourself more. What have you been telling yourself over and over that you've been ignoring? *Turn to page 160*

Spiritual Journey: Do you believe in miracles? Have you ever witnessed a miracle or had one of your very own? Write about miracles and how they affect you. *Turn to page 160*

Destination Journey: What are you passionate about? What fuels that passion? How can you turn your passion into your calling? *Turn to page 162*

Humanitarian Journey: Write about a local organization that makes a big difference in your community and specifically what they do. *Turn to page 166*

Overcomer's Journey: Seek out more peace. Find things that make you feel peaceful, do more of these things. Practice peaceful habits like: avoiding arguments, violent movies/shows and negative people. What things do you plan on doing to seek more peace? *Turn to page 170*

Chaotic Resolve Journey: Cut out excessive spending and save more money. Write about things you spend too much money on and how you can save more money. *Turn to page 174*

Achievement Journey: Keep brainstorming. This keeps you creative and compels you to think. Thinking outside the box at times is also beneficial. What do you find yourself brainstorming about? *Turn to page 178*

Self-discovery Journey: Have you ever been in a play or performed in a community theatre? What role in any play would you be best at and why? *Turn to page 182*

Writing a New Chapter Journey: Did a mistake ever give you an "ah-ha" moment? Explain the moment in detail. *Turn to page 186*

Mending Fences Journey: Be the change. Gandhi told us to, "be the change we want to see in the world." Do you currently live up to this? How can you start being the change? *Turn to page 190*

Self-improvement Journey: Love your own image. Join an online group dedicated to promoting self-love. Write about the group and any new people you met and if it made a difference in your life. *Turn to page 194*

Spiritual Journey: Do you think there is a difference between spirituality and religion? Describe the two in your own words and how you practice each. *Turn to page 198*

Your Journey Retrospectives

Destination Journey Retrospective

Finding your life's purpose or true calling

1. Do you feel like your true calling must be something you're passionate about, something you're good at or something that pays the bills?

2. What did you learn about yourself through this journaling process?

3. What does your heart keep telling you?

4. What reservations do you have about pursuing your true calling and why?

5. What is your dream profession or job? Do you think that is your true calling?

Destination Journey Retrospective

Finding your life's purpose or true calling

6. At this point in your life, what do you think your life's purpose is and what led you to this answer? Do you think this decision will change at some point in the future?

Humanitarian Journey Retrospective

Make a difference in the world

1. When you think about making a difference in the world, what's the first thing that comes to mind and why?

2. Why do you think one person can make a difference?

3. Describe the kind of person you want to be and why you feel it's important to make a difference in the world?

4. What is something new you learned through this journaling adventure that can help you be a better humanitarian?

5. What cause or issue are you most concerned about and how do you plan to help?

6. Do you think it's more important to focus your energy in your own back yard where you live, like your community or in other countries for those less fortunate? Do you think it's more important to raise awareness, money or get hands-on involved and why do you feel this way?

Overcomer's Journey Retrospective

Conquering your fears

1. What's the most helpful thing you learned while addressing your fears?

2. Did you discover anything contributing to your fears you can change quickly or easily?

3. What's something new you're trying that you hope will help you with your fears?

4. What advice would you give someone who is also trying to conquer their fears?

5. How do you know the fear you have is really fear? What clues led you to know this is something you were really afraid of?

Overcomer's Journey Retrospective

Conquering your fears

6. Were you able to overcome at least one fear by the end of this journey? If yes, how did you do it and how do you feel now? If no, what do you think it will take and why?

Chaotic Resolve Journey Retrospective

Achieving inner peace

1. How chaotic was your life at the beginning of this journey and what was causing all the chaos?

2. What did you learn about yourself that was preventing you from having peace in your life? What is the one thing you changed immediately?

3. What was the hardest truth you had to face on the journey to achieve peace?

4. What do you love most about the feeling of peacefulness and did you discover something on this journey that gives it to you?

5. Have you found the peace you're looking for or are you on the road to get there?

Chaotic Resolve Journey Retrospective

Achieving inner peace

6. Thinking about your life and moving forward, how hard will it be to continue your journey towards peace? Do you think this is something you can achieve, or will it be an ongoing battle? What will be your biggest obstacle?

Achievement Journey Retrospective

Creating new goals

1. How realistic were your goals at the start of this journey? Were you challenging yourself enough or setting the bar too low?

2. What did you discover about your work ethic as it pertains to your dreams and goals?

3. Did you make any major life changes through this experience?

4. How did your dreams and goals change through this journaling process? Talk about what changes you made or why you didn't make any.

5. Is anything or anyone still standing in the way of your dreams or goals?

Achievement Journey Retrospective

Creating new goals

6. Thinking about your future, where do you want to be in the next 5 years, 10 years and then 20 years?

Self-discovery Journey Retrospective

Exploring your true creative passions

1. What new self-discoveries did you make concerning your creative side?

2. Did you find a spark or connection with a specific passion or hobby you forgot was there or missed due to lack of time? How are you planning on reconnecting?

3. How deep was your self-reflection during this journey and did it give you a wake-up call in any area of your life?

4. How much creative freedom were you giving yourself in your own life?

5. Did you find anything missing from your life? If so what was it and what are you going to do about it?

6. How do you feel about your life right now and what changes moving forward are you planning to make? Does any area of your life feel incomplete, if so how?

Writing a New Chapter Journey Retrospective

Learning from past mistakes

1. What was the scariest or hardest thing about facing your mistakes?

2. How have you changed your thinking as a result of this journey?

3. Were any relationships impacted through this process? If so, why and how were they impacted?

4. What is the most positive thing you take away from this journaling adventure?

5. What one thing did you find yourself thinking about over and over while completing these prompts?

6. What do you need to do to complete this new chapter in your life? How does it feel to be working on a new chapter in your life and what will you do different going forward?

Mending Fences Journey Retrospective

Righting my wrongs

1. How hard was it for you to face all of the wrongs you've done? What was the hardest part?

2. Have you changed the way you treat people around you?

3. What one thing do you feel most remorseful for and why?

4. Has your opinion of yourself changed during this process, if so how?

5. What shortcomings did you learn about yourself that you're taking a serious look at now? Have you addressed any of your internal issues?

Mending Fences Journey Retrospective

Righting my wrongs

6. Are you planning on repairing any damaged relationships moving forward? How will you be different with new people or relationships after this reflective journey? What bad trait are you leaving behind?

Self-improvement Journey Retrospective

Loving yourself through acceptance

1. In what ways were you too hard on yourself or not enough loving?

2. How are you going to be kinder to yourself?

3. What one thing made you feel the way you did about yourself before? Why did it have such an impact on you?

4. What good things have you added to your life because of this journey and how has it helped?

5. Do you look at yourself differently now after this journey? Do you see yourself better or worse and why?

Self-improvement Journey Retrospective

Loving yourself through acceptance

6. Write about the beautiful person you are today. What about your beauty is unique and original? Describe your internal and external beauty in your own words.

Spiritual Journey Retrospective

Exploring your beliefs

1. What was the hardest thing to understand about your spiritual journey?

2. Was there anything you didn't like about this journey and why?

3. Did you gain anything from this journey, if so what?

4. Did you discover any new beliefs and if so what?

5. Did you find any differences between your religion and spirituality, if so what?

Spiritual Journey Retrospective

Exploring your beliefs

6. How in touch were you with your spiritual side at the start of this journey and how did it change throughout this process? Do you have a new sense of enlightenment or do you feel differently about anything now?